EGG TEMPERA PAINTING
TEMPERA UNDERPAINTING
OIL EMULSION PAINTING

A Manual of Technique

BY

VACLAV VYTLACIL

and

RUPERT DAVIDSON TURNBULL

NEW YORK

OXFORD UNIVERSITY PRESS

1935

CONTENTS

INTRODUCTION

THIS book has two functions. It is partly a text-book, or manual of technique, and partly an essay. As a text-book it contains full directions for painting in Egg Tempera and for the making of the necessary grounds. As an essay it outlines a new method of painting in oil or oil emulsion, with suggestions both theoretical and practical. There is a logical connection between these two functions or we should not have included them in the same book. •

As a text-book on tempera painting, we have given directions, as precise and clear as possible, for the making and use of those forms of egg tempera which we have found in the course of several years of experimenting to be the important fundamental forms. There are many variations of these forms which anyone, with the experience these fundamental forms provide, can work out to suit his own taste. As the use of the right ground is of the utmost importance in both tempera and oil painting, we include full directions for the making and use of the most important tempera and oil grounds.

The student who wishes a clear and concise manual of technique on tempera painting alone should find here all the information necessary, and in as practical a form as possible. It seems to us, however, that there is another important aspect of tempera; that is, its suitability as an underpainting for oil or oil emulsion. We have therefore given precise and practical directions on the preparation and use of tempera as an underpainting.

If it seems to the reader that the language used is sometimes too elementary, it has been used deliber-

1

ately, as it has always seemed to us that most manuals of technique are too vague and general in their directions. There is also a certain amount of repetition both of theories and directions. This again is done deliberately either for the sake of clarity or to emphasize certain important points, since it is one thing to read about a handicraft, but a much more difficult process to perform the actual handicraft according to written directions. It has always been our experience in following notes on the technique of painting, that it is impossible to have the notes too precisely or too clearly stated.

We would like to thank Mr. Jacques Maroger and the French Academie des Sciences for permission to use their articles on the Maroger Oil Emulsion, and M. Georges Mourier-Malouf for his help in reading and criticising the book in manuscript.

All through our experiments we have found Max Doerner's "The Materials of the Artist" an invaluable source of information, inspiration, and suggestions. For a really monumental and authoritative treatise on practically all techniques of painting, this book cannot be too highly recommended.

Our purpose in the present manual is not to cover the whole field of the technique of painting, but to point out and describe a logical series of steps in picture-building, beginning with the simplest forms of lean tempera painting, through several forms of fatter pastose tempera painting, to the final overpainting in oil or oil emulsion.

We have obtained such excellent results from this method of painting that we feel justified in claiming for it first, that it is a more craftsmanlike, more permanent, and more beautiful method of painting than the ordinary oil painting as practised today, and secondly,

that if it is not the technique of such Old Masters as Rubens, Rembrandt, and the great Venetian colourists, it is at least a technique closely resembling theirs. Once mastered, effects similar to theirs grow easily and naturally out of the characteristics of this method of painting.

This can hardly be said of modern direct oil painting.

NOTE ON OIL PAINTING AND TEMPERA PAINTING

FOR those who have never painted in tempera, the following notes on its chief characteristics and its points of difference from oil painting may be of value.

OIL PAINTING

1 : Is essentially a fat "pastose" * medium.

2 : Consumes much time in waiting for each coat to dry thoroughly.

3 : Dries from the outside in, forming a skin outside which slows down the drying process, especially in thick masses of paint.

4 : Changes colour over a long period of time, owing to the darkening and yellowing of the linseed oil.

5 : Clogs up the surface of the canvas with greasy, sticky paint, making it difficult to change or correct without dirtying the colour.

6 : Is somewhat difficult to handle in the actual painting, because of clogged-up brushes, palette, etc.

7 : Has a shiny surface which is less suitable for large pictures or murals.

8 : Must be varnished from time to time to bring it back to its original freshness.

But—

9 : Is perhaps better for painting in fine nuances, or for tonal light and shade painting.

10 : Lends itself well to soft blended luminous effects.

* "Pastose," as used in this book, means thick, opaque paint quality, in contrast to thin, transparent or semi-transparent paint quality.

4

11 : Permits strong personal temperament to express itself in the brush-work, etc.

12 : Is decidedly more expensive than tempera painting.

TEMPERA PAINTING

1 : Is essentially a thin lean water-colour medium. Only certain forms of tempera lend themselves to pastose painting.

2 : Dries quickly, permitting rapid work. A painting finished one evening is ready for exhibition the following morning. This is important for mural work, decorations in public places, etc.

3 : Dries, or rather sets, as a mass all through, in a very short time. Then follows a slow hardening process, of perhaps a year or more, during which the egg content becomes insoluble in water.

4 : Once dry, changes hardly at all, certainly far less than ordinary oil painting.

5 : Always presents a clean dry surface on which it is easy to make changes or corrections. This is ideal for laying in a composition in underpainting.

6 : Is clean and easy to handle in the actual painting, one brush being enough, and both brush and palette being easily cleaned with water.

7 : Has a dull mat surface, ideal for big pictures, especially murals.

8 : Does not need varnishing, one of its chief charms being the dull surface it has. A sheet of glass over it gives a richer surface glow, if desired.

9 : Is perhaps better for painting in large planes of colour, as fine nuances tend to disappear in tempera.

10 : Lends itself well to precise detail, crisp lines, sharply defined edges, etc.

11 : Does not afford expression of personal temperament in the brush-work, etc., as easily as oil.

12 : Is decidedly cheaper than oil painting.

SUMMARY

WE feel that most artists will agree with us when we suggest that the "ideal" medium would be that one which combined the advantages of both the above mediums, but was free from the disadvantages of either.

Such a medium should be free from all darkening, yellowing or cracking, any changes of colour in drying, but should possess the freedom and ease of handling of tempera, the richness and softness of oil, the precision of detail of tempera, the blending and luminosity of oil, the airy transparence of tempera, the pastose solidity of oil, the permanence of tempera, the clean surface of tempera, the personal temperamental quality of oil, and last, but not least, the cheapness of tempera.

The nearest we have ever come to this imaginary "ideal" medium is the process, described in this book, of combining on the same canvas tempera painting with oil emulsion painting so as to have as many of the virtues of each, while eliminating as many of the disadvantages of each as possible; that is, of doing the major part of the painting in the tempera underpainting, reserving the oil or oil emulsion for the final effects only. (For details see *Maroger Oil Emulsion*, p. 61; *Notes on Underpainting*, p. 13; *Summary of Procedures*, p. 67.)

OIL PAINTING

THERE are almost as many theories about the "Secrets of the Old Masters" as there are artists or art critics. Whenever two or three artists get together in front of a Rubens, an El Greco, a Titian, or a Rembrandt, the discussion begins all over again. It runs more or less as follows: How did these men achieve their effects? How did they get such airy transparence in contrast with such richly modelled pastose? How did they avoid all hint of greasiness or slippery smooth oiliness? How did they make the colours glow with such a luminous intensity? Why do their canvases remain in good condition, centuries after they were painted, while ours begin to yellow or darken or crack within a comparatively few years?

This sort of discussion, so common among artists and students, usually ends with agreement upon one point only: that is, that however these Old Masters painted, they did *not* paint the ordinary oil painting as it is taught in most schools today. If any one doubts this statement, let him try to copy a particularly luminous Rembrandt head, using the ordinary oil paint, and see what he gets for his pains. Or to save time, let him walk through any great art gallery and compare the works of the laborious copyists with the originals. The first thing most copyists reach for in their efforts to achieve luminosity is varnish, as it is always possible, by using varnish mediums, to arrive at some sort of luminosity. But it is never the luminosity of a Rembrandt. It is more apt to be some sort of unpleasant "stained-glass" luminosity, plus a slippery, glittery surface that is worlds apart from the beautiful surface texture of the original.

By using the methods of underpainting and over-painting described in this book, it is not merely possible to achieve similar technical effects to those of a Rembrandt, a Rubens, etc., but these effects come easily, freely, and naturally out of the nature of the mediums employed; so easily and naturally, in fact, that we feel justified in suggesting, not that this is the "Secret of the Old Masters," re-discovered at last, but that it is a method so closely approximating some of the best of the older methods of painting that it is worth careful study and, possibly, further individual development.

> *Note:* We are not for a moment advocating that all methods of painting must be judged by their resemblance to or imitation of the above-mentioned Old Masters. We have used the technical effects of their works solely as a test or standard, since the whole world has agreed that these men were masters of a supremely fine method of painting.

Stated shortly and somewhat crudely, this method is as follows: The major part of the painting is laid in in some form of tempera painting, including the pastose portions, and the oil painting is reserved for a final enrichment or enhancement of the surface, and is done in some form of oil emulsion, rather than in oil alone or oil and varnish alone. (See further under *Notes on Underpainting*, p. 13; *Maroger Oil Emulsion*, p. 61; and *Summary of Procedures*, p. 67.)

For a masterly exposition of the "Technique of the Old Masters," see under that heading in Max Doerner's book "The Materials of the Artist." Starting with the ideas suggested therein, we began a series of experiments lasting over several years on the use of tempera as an underpainting. During the course of these ex-

periments we became acquainted with the *Maroger Oil Emulsion* or "Maroger Medium," and were at once struck with the possibilities of combining the two mediums in the same picture. The reason for wanting to combine the two is that tempera painting permits the greatest freedom in first beginning a canvas, allows of endless changes and corrections until the composition sits precisely as the artist wishes it to, without clogging up the surface, whereas the "Maroger Medium" is essentially a sticky, tacky medium which gives great variety and beauty to the surface of a finished canvas, but does not lend itself easily to changes and corrections, except of detail.

The importance of this for large canvases or panels for murals (wet fresco apart), can hardly be exaggerated. Every artist who has been faced with the problem of laying in a composition on a big surface of wall-space will realise at once the desirability of having a medium which dries rapidly, which permits him to make radical changes and corrections, and at the same time permits him to develop his colour structure without spoiling the surface for further painting. For such a purpose, tempera is almost ideal, whereas oil painting is about as unsuitable as possible.

Examination of the paintings in the chief European galleries with this theory in mind served merely to confirm the opinion so clearly and logically developed by Doerner, that is, that *all* the best painting (wet fresco apart) up to and into the Eighteenth Century was:

1 : Some form of tempera left as a tempera painting;
2 : Tempera underpainting, with some form of oil or varnish overpainting;
3 : A combination of the two, painted more or

less simultaneously. (See discussion of the "Mixed Technique" in Doerner, or under *Summary of Procedures*, p. 67, at the end of this book.)

The only addition we would make to Doerner's opinion is, as stated above, that the final painting also was done with an emulsion, probably some form of oil-emulsion, if not identical with the *Maroger Oil Emulsion*, (see p. 61,) at any rate closely resembling it.

> *Note:* Ordinary oil paint, when used with a varnish medium, such as 1/3 Oil, 1/3 Damar varnish, 1/3 turpentine, and painted as an overpainting on a well prepared tempera underpainting, will give effects closely resembling those of the Old Masters, but never to the same degree, or with the same facility, as the "Maroger Medium" affords.

For a fine example of tempera underpainting, see a large "Madonna and Child" by Parmagianino in the Naples Museum. The background and shadows are very thinly painted, the colour barely suggested, the lights and modeling strongly built up with some form of Putrido * or Pastose Tempera, the whole picture in an ideal condition for enrichment by overpainting with some sort of oil medium such as the "Maroger Medium." For a different type of underpainting, see the Giovanni Bellini, "Christ in the Tomb," in the Accademia at Venice. This is painted very thinly and very light in key, in grayish-green monochrome (probably terre verte), on a smooth panel, with no pastose painting, the whole picture ready for glazing and overpainting with thin transparent colour, the modeling and shading being worked out completely in the painted drawing.

* See p. 32 for definition and description of Putrido Tempera.

Note: These two pictures are mentioned as examples of technique only, unfinished paintings by the Old Masters being rare, and seldom on exhibition.

The fundamental disadvantages of direct oil painting seem to be inherent in the qualities of linseed oil. (See further under *Linseed oil,* p. 53.)

By underpainting with tempera and overpainting with oil or oil emulsion, all the beauties of oil painting are retained, but by reducing the content of linseed oil in the picture, the dangers and disadvantages of oil are reduced to a minimum. (See Moreau-Vauthier's book, "Painting," for further discussion of the dangers of too much linseed oil in a painting.)

Theory of "Fat" and "Lean": When ordinary oil paint is painted on top of another layer of oil paint, the result is "fat" on top of "fat," or technically speaking, linseed oil on top of linseed oil. If this is repeated often enough, or too thickly, the surface becomes greasy or clogged up with pigment, and the successive layers of "fat" on "fat" show a strong tendency to sink into one another, the result being heaviness or muddiness, especially in the darker colours. In the experiments described in this book, however, we have found that where "fat" is painted on top of "lean," e.g., Putrido on top of Lean Tempera, or Oil on top of Putrido, the surface of the canvas remains far cleaner and more easily controlled, and the layers of "fat" colour, though binding securely and strongly to the "lean" under-painting, show little or no tendency to sink in.

Note: It should be noted that the words "fat" and "lean," as we use them in this book, refer solely to the qualities inherent in the mediums used, *not* to the thickness of the painting.

Thus, an underpainting in "lean" tempera may
be quite thickly painted, even heavily pastose,
but a thin glaze of oil or oil emulsion over the
thicker painting remains a case of "fat" on top
of "lean."

Conversely, "lean" may be painted on top of
"fat," even while the "fat" painting is still fresh,
e.g., Lean Tempera on top of Putrido or Oil
Emulsion, but only under certain conditions and
in a limited way. (See Example 5, Mixed
Technique, under *Summary of Procedures*, p.
70).

NOTES ON UNDERPAINTING

IT IS difficult to give precise directions on underpainting, partly because each artist will certainly wish to develop his own method, and partly because a great deal of experience is necessary before the full beauties of this method of painting can be developed. The following notes, therefore, are in part theoretical and in part practical.

When we consider the most important difference between modern direct oil painting and the method of underpainting and overpainting advanced in this book, then one fact of importance to the artist becomes apparent at once : in direct oil painting the artist works for the final effect, both in form and in colour, from the very beginning through all stages of the painting. In using underpainting, he works for the final effect in form from the beginning, but he must learn to think of the final colour effect as a separate stage to be arrived at indirectly.

The first effect of this on the artist will probably be that he feels himself hampered in the free expression of his artistic impulse. It will seem to him that he is tied down to a schematic, mechanical routine of procedure which comes between himself and his picture. The immediate result of this will probably be that his first pictures look hard and stilted in form, and distinctly inferior in colour. At least, that was our experience.

This result is so discouraging that the artist, after a few experiments, is sorely tempted to drop the whole matter and go back to his direct oil painting. However, it is purely a question of mental habit plus experience. Once he has learned to think in terms

of underpainting, and begun to master the technical difficulties, he will find that he has at his command *all* the effects of which direct oil painting is capable, plus a whole range of new effects which only underpainting can yield. By submitting to the mental discipline imposed by the method of underpainting, he will find eventually a wider and freer means of expression than he already possesses in direct oil painting. What he loses in the speed of execution, for the use of underpainting is always slower, he gains in the added beauty and richness of his picture, plus the satisfaction of working in a more craftsmanlike manner for a more durable and permanent result.

The following notes, of a more practical nature, are based on our experience with the use of underpainting, and are put forward more as cautions or suggestions to aid the beginner than as precise instructions :

1 : The underpainting should not attempt at any stage to give the final colour effect of the picture. If this is done, then the final painting becomes merely an imitation or a repetition of the work already done.

2 : The composition should be set as precisely as possible in the underpainting. When the final painting is done with the Maroger Medium, it will be found that the less radical correction necessary, the better.

3 : The underpainting should be done in the most permanent medium possible, since it is obvious that any changes in colour or deterioration in material in the underpainting will have serious consequences for the final painting on top of it.

4 : The underpainting should be of a lean, hard, non-absorbent character.

5 : The underpainting should be kept as light in key

as possible. This is an important factor in the long life of a picture. The results of painting on a dark underpainting or a dark ground are almost certainly responsible for the darkening seen in some of the canvases of Tintoretto, Bassano, or Poussin, for example, in many of which the dark supporting ground has come through so strongly that the pictures are almost entirely brown or in some cases almost black. To develop strong compositional form in the underpainting, ·and at the same time to avoid dark heavy colour, it is necessary to use strong contrasts of cool and warm colour, both adjacent to one another and over one another. For example, light cadmium yellow in its full intensity remains light in key for the scheme of an underpainting. But the heavy browns or blues should be avoided, except when strongly raised with white.

6 : The pastose parts may be built up entirely in the underpainting, by the use of Putrido, (see p. 32) but as this sort of pastose when later glazed gives a very different effect from pastose painted directly during the final painting, most painters will probably prefer to avail themselves of this variety of effect by using both methods.

7 : A common method of painting is to begin with a drawing on the canvas, over which a general tone is scumbled, and into this tone the painting is done. This may even be combined with slight glazing later for final effects. But this is not to be compared with a sound structural system of underpainting.

The above practical hints should always be tempered by the following artistic considerations :

The beauty of the overpainting depends largely on the proper supporting contrast in the underpainting ; for example, warm final colour over cool — cool final

colour over warm — thin intense final colour over some contrasting colour — thin pale final colour over intense colour in the underpainting — complementary colours — contrast of thick and thin, both as space-building elements in the composition, and as an enrichment of the picture surface, and so on.

By stressing this contrast of thick and thin, the artist avoids the monotonous effect of a uniform thick coating of paint, so common in ordinary oil painting.

As a general rule, it is better to keep the dark colours thin and transparent, reserving the pastose effects for the lighter colours.

The character of an underpainting should be fundamentally structural; that is, it should be developed in large simple areas of colour. Delicate half-tones and fine nuances should be reserved for the final painting.

TEMPERA PAINTING

In Tempera Painting the pigment is applied to the surface to be painted on by means of an emulsion.

> *Note* 1 : An emulsion is the close binding to-
> gether, by means of a "vehicle," of two or more
> dissimilar substances, e.g., linseed oil and water,
> which do not ordinarily combine. The two ve-
> hicles most commonly used in tempera painting
> are Egg and Glue.
> *Note* 2 : Water colour, Gouache and Glue
> Tempera, though for convenience sake usually
> grouped as tempera painting, are not strictly so,
> the binding medium being simply glue or gum
> arabic dissolved in water.

It should always be remembered that the essential quality of tempera is that it is a "water" medium, and not an "oil" medium. Artists accustomed to oil painting always find it difficult at first to adjust their painting to this fact. (See *Pastose Tempera,* p. 25, for forms of tempera approaching oil.) At first, discouraged by the absence of those qualities they are accustomed to in oil, they seek to force such qualities into tempera, usually by enriching the emulsion, i.e., by making it "fatter" with more egg, more oil, more varnish, or more of all three. This is wasted effort. Tempera so treated lacks the beauties of either oil or tempera, and the result is usually a dark, heavy, unpleasant effect. If oil effects are wanted, they must come as a separate step by means of overpainting on top of the tempera.

The important qualities of tempera are its thinness and leanness, its transparence, its dull mat surface, its permanence.

17

THREE MAIN FORMS OF TEMPERA

LEAN TEMPERA

Emulsions	Colours
1 Egg, 2 Water	Ground in
1 Egg, 1 Damar, 2 Water	1 Egg, 1 Damar, 2 Water

MEDIUM FAT TEMPERA

Emulsions	Colours
1 Egg, 7 Linseed Oil, 2 Water	Ground in
	1 Egg, 1 Oil, 2 Water

Combination White may be used with this form of tempera.

PASTOSE TEMPERA

Emulsions	Colours
1 Egg, 1 Oil, 2 Water	Ground in
1 Egg, 1 Sun-thickened Oil, 2 Water	1 Egg, 1 Oil, 2 Water or As Putrido

Combination White or Putrido White should be used with this form of tempera.

Explanatory notes on this summarized table follow immediately. For the making of emulsions, see under *Emulsions,* p. 22 ; for Combination White, see under *Rubbing of Tempera Colours,* p. 28 ; for Putrido White, see under *Putrido,* p. 32 ; for Sun-thickened oil, see under *Linseed Oil,* p. 53.

There are however certain forms of tempera which do permit of thick pastose painting. For the purposes of this book, we have arbitrarily made the following three groups : —

 1 : LEAN TEMPERA
 2 : MEDIUM FAT TEMPERA
 3 : PASTOSE TEMPERA

1 : LEAN TEMPERA : By Lean Tempera we mean colours ground in the following emulsion : 1 Egg, 1 Damar, 2 Water, and painted with either the same

emulsion or with 1 Egg, 2 Water. This form of tempera permits of practically no pastose painting. The colours go on in thin transparent washes, unless white is added to make them more opaque. Even the white, especially zinc white, when painted thinly with a lean tempera emulsion is rendered transparent. It permits of almost endless changes and fine adjustments without getting the surface clogged up with fat oily paint. It dries very quickly, within five or ten minutes, permitting very rapid painting.

2 : MEDIUM FAT TEMPERA. By Medium Fat Tempera we mean colours ground in the following emulsion : 1 Egg, 1 Linseed Oil, 2 Water, and painted with the same emulsion. As in all forms of tempera, it may be thinned out with water for thin transparent effects. When used too thickly, there is a tendency especially in the darker colours for one colour on top of another to sink in gradually, within half an hour or so, the final effect being somewhat heavy and sombre. The surface when completely dry is very dull or mat. Fine nuances within the colours have a tendency to sink in and disappear when dry.

It is possible to paint more thickly with the Medium Fat Tempera than with the Lean Tempera, but experience is necessary to show how thickly it is safe to paint with it. Artists accustomed to direct oil painting are likely to paint too thickly with it. Where a more pastose quality is desired it is always better to switch to either Putrido White or Combination White, instead of the white rubbed up with this emulsion.

3 : PASTOSE TEMPERA. By Pastose Tempera we mean tempera painted as thickly as oil paint. This may be done as follows : by grinding a complete palette of colour as *Putrido* (see p. 32) and painting with either the 1 Egg, 1 Oil, 2 Water emulsion, or for

thicker painting, the 1 Egg, 1 Sun-thickened Oil, 2 Water emulsion. It is also possible to paint fairly pastose by using all the colours except white ground in the Medium Fat Tempera emulsion (see above), and using either Putrido White, or Combination White, and either of the above emulsions.

For the building up of the pastose parts of an under-painting meant to be finished in oil, we recommend the use of Putrido or Combination White as above. The reason for this is that these set as a mass all through, instead of forming a skin and drying from the outside in, as oil paint does.

When the sun-thickened oil emulsion is used, Pastose Tempera dries with a slightly glossy surface. When completely dry, it may be varnished, and then closely resembles an oil painting. (See Examples 3 and 4, *Summary of Procedures*, pp. 68-69.)

All the above forms of tempera have their distinguishing characteristics. Each may be left as a straight tempera picture, regardless of whether it also serves as an underpainting or not.

Except for Putrido or Pastose Tempera (see immediately above), tempera pictures should not be varnished. It is possible to spray the Lean Tempera painting with a 5 per cent solution of animal gelatine in water, to toughen and protect the surface. White of Egg Varnish, made by beating up the whites of egg and allowing it to stand overnight, then using the clear liquid which settles at the bottom as a varnish, is sometimes recommended as a varnish for certain forms of tempera pictures, but Doerner strongly cautions against this as the white of egg is liable to turn brown with age. If a richer surface glow is desired, it may be more safely obtained by putting a sheet of glass over the picture.

It should be remembered that the classifications into three forms of tempera made above are purely arbitrary, and have been made solely for the sake of clarity in discussing or describing the possibilities of tempera painting. There is a wide field for experiment in combining different emulsions with colour ground in different ways, and with the experience gained in making and handling the above forms, every artist may experiment until he finds that form which best suits his own temperament.

EMULSIONS FOR TEMPERA PAINTING

GOUACHE
EGG AND WATER
YOLK OF EGG AND WATER
LEAN TEMPERA
MEDIUM FAT TEMPERA
PASTOSE TEMPERA

Note 1 : The simplest method of mixing the following emulsions is to use one egg as the unit of measure. Cut a small hole in the top of the egg, pour out the contents, and use the empty shell for measuring out the oil, varnish, and water, etc. This has the advantage of not making too much emulsion at one time. It will be found, especially in hot weather, that the emulsions go bad if made in large quantities, unless, of course, you are painting unusually large pictures. In hot weather it is advisable to stand the emulsions in a dish of cold water, or better still; in an ice-box.

Note 2 : The greatest care must be observed to use only bottles or jars, for the emulsions, that are *absolutely clean!* Bottles that have contained an emulsion that has gone bad *may,* by being boiled in soapy water and then soaked in some strong disinfectant, be used again, but we have always found that it saves time and is safer to throw away such bottles and use fresh ones, as the slightest particle of the old bad emulsion is enough to make a fresh one turn bad very quickly.

Note 3 : The following procedure is recommended for the making of *all* the above emulsions : — *Always* begin with the egg. Put it in a bottle, preferably a short fat bottle, cork it

tightly and shake vigorously, till the yolk and white are well mixed. Then add the oil or varnish and again shake for one or two minutes. *Always* add the water last, and then shake vigorously for at least five minutes, better for ten minutes.

GOUACHE: See separate article on *Gouache*, p. 59.

EGG AND WATER: 1 Egg: 1 Water to 2 Water as desired. This emulsion may be used with ordinary Gouache colours in tubes, with dry colours ground in the same emulsion, or with colours ground in the *Lean Tempera* emulsion. It is especially good where thin transparent painting is desired, and should not be used for pastose painting. It works well on the *Chalk Ground*, p. 36, or on the *Tempera Panel*, p. 40.

YOLK OF EGG AND WATER: There is no formula for this form of tempera painting. The colour is ground in water. The yolk of the egg is carefully separated from the white, and is used as a medium into which the brush is dipped before taking any colour on it. It gives especially thin transparent effects, and works best on a fine smooth panel. (See *Tempera Panel*, p. 40.)

LEAN TEMPERA: 1 Egg
 1 Damar varnish (1 to 3 solution, see *Damar Varnish*, p. 56)
 2 to 3 Water

This emulsion gives a good form of tempera either for underpainting when used thinly, or for a picture left as a straight tempera painting. In the latter case it may be painted fairly thickly, but a little experience will soon show how thickly it is safe to paint with it,

and where it is best to switch to *Pastose Tempera,* (see p. 25), or *Putrido,* (see p. 32,) for really thick painting. When used thinly it goes very well on the *Chalk Ground,* (see p. 36,) but for thicker painting it is advisable to use the *Tempera Ground,* (see p. 39). This form of tempera gives effects similar to *Gouache,* but dries out and hardens with time into a strong surface so much more permanent and durable that we recommend its use in preference to Gouache.

MEDIUM FAT TEMPERA: 1 Egg
　　　　　　　　　　　1 Linseed Oil
　　　　　　　　　　　2 Water

This emulsion gives effects very different from the *Lean Tempera* just described. A certain amount of practice with it is necessary to handle it well. When the painting gets at all thick, the colours, especially the darker ones, have a strong tendency to sink in, and fine nuances tend to disappear. The surface when dry is very mat and dull.

> *Note:* With this emulsion one is often tempted to try for greater luminosity in the colours or a richer gloss on the surface by adding more oil and less water, or a little varnish and less water, but this will probably be found to be a waste of time, effort, and materials. The mat surface is characteristic of this form of tempera. If a glossy surface or a surface which can be varnished is desired, we recommend the *Pastose Tempera* emulsion (see immediately below).

With the Medium Fat emulsion one should always use the *Tempera Ground* (see p. 39) or the *Tempera Panel* (see p. 40). The *Chalk Ground* is too absorbent.

Colours ground in this emulsion may be used as an underpainting, or left as a straight tempera painting. It is a good emulsion to use with colours ground as *Putrido* (see p. 32).

PASTOSE TEMPERA : 1 Egg
 1 Sun-thickened Linseed Oil
 2 Water

> *Note* 1 : The sun-thickened oil may be too stiff and sticky to be put easily in a bottle. It is best to rub it up with the egg on the glass palette, using a palette knife. The egg breaks down the stickiness of the oil, and the resultant mixture may then be put in a bottle, the water added, and the emulsion shaken together.

> *Note* 2 : This emulsion is not good for grinding colours. It should be used solely as a painting emulsion, with colours ground in the *Medium Fat Tempera* emulsion (see immediately above) or with colours ground as *Putrido* (see p. 32).

This emulsion is the best for all forms of tempera painting where thick pastose painting is desired, e.g., for building up heavy lights as an underpainting for later glazes in oil or Maroger Medium. Left as a straight tempera painting, it should dry with a faint gloss and this may be strengthened by later varnishing, after four to six months, with a weak solution of Damar varnish 1 to 5 (see *Damar Varnish*, p. 56). It should be painted on the *Tempera Ground* or the *Tempera Panel*. Owing to the stickiness of the sun-thickened oil, it will be found that the brush does not wash out in water as easily as with the other emulsions. Every so often it is necessary to wash the brush thoroughly with soap and water. If it is found to be too sticky, the sun-thickened oil may be diluted by rub-

bing a little sun-bleached linseed oil into it before making the emulsion.

In contrast to the leaner forms of tempera, this emulsion is so "fat" that it is possible to paint into it with the Lean Tempera as if it were ordinary oil paint, but only within certain limits. (See under *Summary of Procedures*, Example 5, p. 70.)

> *Note* 1 : The above formulas are those which we believe to be the most important for all ordinary forms of tempera painting. At least we have found them so, after several years of experiments with many other emulsions. But they may be varied within certain limits, and each artist will certainly experiment with them until he finds those proportions which best suit his own temperament and technique. It should be noted, however, that the variations should take place more or less within the limits of quantity of each formula; for example:
>
> LEAN TEMPERA : — 1 Egg, 1 Damar, 2 Water.
> Limit of quantity, ═ 4 measures.
> Variation 1 : — (fatter) — 1 Egg, ½ Damar, ½ Oil, 2 Water.
> Limit of quantity still remains 4 measures.
> Variation 2 : — (fatter and thicker) — 1 Egg, 1 Damar, ½ Oil, 1½ Water.
> Limit of quantity still remains 4 measures.
> Variation 3 : — If you make it 1½ Egg, 1 Damar 2 Oil, 1½ Water, the limit of quantity becomes 6 measures, and the resulting emulsion will be found to have totally different characteristics.
>
> *Note* 2 : There are certain commercial preparations on the market sold as Egg Tempera Emulsions. These are liable to contain some strong preservative or disinfectant to prevent the egg from going bad, and these disinfectants sometimes have a bad effect on certain colours. They vary greatly in quality and should be used with caution.

Note 3: Emulsions can always be diluted with water, either in the bottle or with the brush while painting, but it must be remembered that it is the emulsion which binds the pigment to the surface, and that if it is too diluted, the colour will not stick.

RUBBING OR GRINDING OF TEMPERA COLOURS

FOR grinding the colours, a large slab of marble is the best. The white marble tops found on old-fashioned tables and dressers are often excellent, if they are not too highly polished. Also a marble block large enough to afford a good grip with both hands should be used for the actual rubbing.

A large sheet of plate glass may also serve, on which the colours can be rubbed with a glass pestle, but the marble slab is better, as the weight of the block of marble is enough to grind the colours thoroughly without any further pressure.

It is important in tempera painting to have a palette that can be easily washed with soap and water at the end of the day. A sheet of glass with white paper under it will serve, or a white enamelled table-top or tray. *All forms of tempera dry and harden so quickly that it is essential to keep the palette and brushes perfectly clean.*

Dry colours may be rubbed up with water only, and painted with one or other of the emulsions, dipping the brush in the emulsion each time before taking any colour on it, or they may be rubbed up with either the *Lean Tempera* or the *Medium Fat* emulsion. In the latter case, which we recommend for most forms of ordinary tempera painting, it is generally best to dip the brush slightly in the emulsion each time as well, but where very thin transparent washes are wanted, the brush can be used with only water in it, the emulsion already in the colour providing sufficient binding medium. The brush is washed out in a bucket of water for each change of colour, and a little experience

28

will soon show how much of this water should be dried out of it and how much may be safely left in the brush.

When rubbing up the colours with an emulsion it will be found that some of them do not take the emulsion as readily as others. If these colours are first moistened with a thin solution of Gum Arabic and water, and rubbed into a stiff paste, they will then take the emulsion without difficulty.

It is better not to rub up too much colour at a time with the egg emulsions or they are liable to turn bad or begin to mildew on top, especially in hot weather. For the very best results, they should be rubbed up fresh every day, but this takes so much time and effort that, in practice, it will be found sufficient to rub up a fresh batch of colour every two or three weeks.

There is no rule as to how long colours should be rubbed. All authorities from Cennini on agree that the longer they are rubbed the better. The individual's strength and patience will, in practice, probably decide the question. Experience will soon show that some colours need more rubbing than others. Those which feel gritty under the marble block, as in certain cheap grades of yellow ochre, should receive a thorough grinding until they feel perfectly smooth.

The colours so rubbed should be kept in jars or glasses, with large openings for ease in cleaning, and should be provided with tightly fitting corks or covers. To prevent them from drying out too fast, put several drops of water on them at the end of each day's painting.

To prevent them from going bad too quickly, add a few drops of *Oil of Cloves* (obtainable at any drug store) when rubbing them up. Since this is a non-drying oil, care should be taken not to use too much. About 3 or 4 drops to ¼ of a pint (half of an ordinary

drinking tumbler) of colour is enough. Vinegar is sometimes used for the same purpose, but Doerner cautions against its use, as it affects certain of the colours, ultramarine for one, very badly.

It is impossible to lay down any rule as to the amount of emulsion to be used with each colour, each artist having his own ideas on the consistency of the colours he uses. Some prefer a stiff paste, others a soft cream. The important thing to watch is that if the emulsions used are thinned out with water, as they may be, there still remains enough strength in them to serve as a binder. Moreover, when the colours are rubbed up with water only, do not forget to dip your brush in the emulsion each time you take any colour on it.

THREE GOOD TEMPERA WHITES

Note on Lead White and Zinc White: Either Lead white or Zinc white may be used in tempera painting. Lead white covers better, and is perhaps less liable to crack when used for thick pastose painting. Zinc white is more transparent, and affords one of the most charming effects of tempera painting, that is, washes of white which are definitely white, yet still remain transparent. In the following notes on Three Good Tempera Whites, either Lead or Zinc white may be used. (See *Lead White,* p. 58).

MEDIUM FAT WHITE: This is white rubbed up with the Medium Fat Emulsion (See p. 24).

PUTRIDO WHITE: This is white rubbed up as Putrido. (See *Putrido,* p. 32.)

COMBINATION WHITE: This is a mixture of the two whites just mentioned above. Take equal parts of Medium Fat white and Putrido white, and rub them

together with a palette knife. It will be found that this white sets more quickly than either of the other two, and it is therefore advisable not to mix more of it than can be used in one day's painting. It is especially good where a very stiff pastose passage is required.

More of the Medium Fat White or more of the Putrido White may be used as it is desired to have this Combination White either more lean or more fat. If it proves too stiff, it can always be softened with a little of the Medium Fat Emulsion, or a few drops of water.

PUTRIDO

PUTRIDO * is a form of fat tempera painting which offers the artist the possibility of thick pastose painting in combination with thin transparent painting. In its handling, it is very similar to oil paint. It is equally flexible, permits of more blending and shading of nuances than the leaner forms of tempera, dries more quickly than oil paint and becomes very hard and tough, drying in the characteristic tempera manner; that is, the paint hardens as a mass all through, instead of as with oil paint, drying slowly from the outside in.

It is so balanced between oil painting and tempera painting that it is possible to paint it as either one or the other. When an emulsion is used, (usually the Medium Fat Emulsion, 1 Egg, 1 Oil, 2 Water,) it paints as tempera, drying with the beautiful mat surface of tempera. When oil is used as the medium (either ½ Oil: ½ Turps, or ⅓ Oil: ⅓ Damar: ⅓ Turps, *never Turps alone*) the painting dries more slowly and with a rich glossy surface which may be later varnished, in which case the picture closely resembles an oil painting.

Putrido works well in combination with the other forms of tempera painting mentioned above, or equally well by itself. Thus, a picture may be begun with large free washes of thin Medium Fat Tempera, very transparent or opaque (i.e., with white in the colours) and into this while it is still wet or fresh, you can paint with brushfuls of thick pastose Putrido, and go on developing the canvas simultaneously with both thick

* Putrido, pronounced "poo-tree-do," is the Italian word for "rotten," and derives its name from the tendency of this form of tempera to decompose and give òff a very unpleasant odour.

32

and thin painting. On the other hand, the whole
painting may be done in Putrido, beginning with it
thinned out and gradually using it thicker up to its full
pastose strength.

It provides an almost ideal non-absorbent under-
painting, especially for the building up of thicker
parts to be later glazed, for the final dressing up or
enhancement of the surface with the brilliant glossy
Maroger Oil Emulsion, (see p. 61).

Putrido colours are liable to go bad very quickly,
especially in warm weather. A few drops of Oil of
Cloves (see above, *Rubbing of Tempera Colours*) will
help to preserve them. In the early stages of decom-
position they may still be used, but when once com-
pletely bad, it is safer not to use them.

The preparation of Putrido is described in an old
manuscript found at Venice, and there seems to be
good ground for believing that it was widely used by
the Venetian painters during the great period of Vene-
tian painting.

PREPARATION :

Take whatever quantity of dry colour you wish to
prepare. Divide it into two equal parts. Rub up
one part with *yolk* of egg *only* into a fairly stiff paste.
Rub up the other part with sun-bleached linseed oil,
to about the consistency of ordinary tube colours.
(To save time or trouble, it is possible to use ordinary
tube oil colours, but to be sure of your ingredients,
it is always advisable to grind your own colour in oil.)
The part that is rubbed up with oil may be slightly
larger in quantity than the part rubbed with yolk of
egg. Then take the two parts so prepared and grind
them together, preferably on the marble slab. It
will be found that when these two parts are put to-

gether, the resultant mixture will stiffen at once into a very stiff paste, too stiff to be easily rubbed. This may be softened down by the addition of either water, emulsion, or linseed oil. If you wish to use the Putrido in its leaner form, add either water or the emulsion (Medium Fat Emulsion), but if you wish to paint with it as oil paint using oil as the medium, then thin it down with oil. In either case, add the water, the emulsion, or the oil very slowly, only a few drops at a time, until the paste becomes a smooth cream easily handled on the marble slab.

Note 1 : It will be noticed, especially when preparing the white, that the use of the yolk of egg makes the colour distinctly yellower. For this reason, it is advisable to use eggs with the whitest possible yolk. Eggs vary greatly in this respect. According to Doerner, however, this yellowing caused by the yolks of egg is not dangerous as the yolk of egg has a tendency to bleach out whiter over a long period of time.

Note 2 : For the same reason, it is advisable in preparing Putrido to use only sun-bleached linseed oil. In these notes, unless specifically stated otherwise, when the use of linseed oil is recommended, we always mean Sun-Bleached Linseed Oil. (See note on *Linseed Oil*, p. 53).

Note 3 : A complete palette of colour may be prepared in either the Tempera Putrido or the Oil Putrido.

Note 4 : A white rubbed up as Oil Putrido works very well in combination with ordinary tube oil colours for the rest of the palette, using oil as the medium. The Putrido white will be found to be a little stiffer than ordinary tube white, and gives pastose effects more quickly and easily. This combination dries more quickly and solidly than ordinary oil paint.

Similarly a Tempera Putrido white works well with a palette rubbed up with Medium Fat Tempera emulsion, using the same emulsion as a medium. (See Examples 3 and 4; pp. 68, 69, *Summary of Procedures*).

A little experimenting will show other possibilities of combining either Putrido white or other Putrido colours with other forms of tempera painting or oil painting.

GROUNDS FOR TEMPERA

CHALK GROUND
TEMPERA GROUND
TEMPERA PANEL
COATED PAPER
CARDBOARD

CHALK GROUND

1 Measure Glue-Water
1 Measure Zinc White
1 Measure Gilder's Whiting

Weigh off 7 parts of dry Rabbit Skin Glue (see note on *Glues,* p. 51) and put it to soak overnight in 100 parts by weight of cold water. In hot weather 5 or 6 hours of soaking may be enough. Then heat the glue and water gently in a double boiler, taking care that it never boils. Too much heat kills the strength of glue. Add a small quantity of sugar, which makes the glue more supple. For about a pint of glue and water, an ordinary pinch of sugar is enough.

Glues vary in strength, so that the above formula, 7 of glue to 100 of water *by weight,* is not necessarily invariable. The best test is that when allowed to cool for several hours, perhaps over night, the mixture just barely jellies. If it remains soupy or liquid there is too much water. If it sets in a stiff rubbery jelly there is too much glue. More water must be added.

Take a well-stretched raw linen canvas that has already been rubbed with flat pumice-stone (see *Canvas,* p. 48) lay it flat on a table, and with a wide thin flat brush apply the glue-water to the canvas by brushing it on lightly, covering the whole canvas as evenly as

possible. *Most canvases are far too heavily glued.*
The ideal to be aimed at is that the glue should go
just half way through the canvas, but this is difficult
to achieve in practice. A certain amount always soaks
all the way through. Use as little glue as possible each
time you dip your brush. On no account should the
canvas be scrubbed with a brush heavily loaded with
glue. It becomes too brittle when dry and is liable
to cause the ground to crack.

Set the canvas to dry, *never* in the sun or by a stove,
for at least 24 hours, better two or three days, then rub
it lightly again with the pumice-stone but only enough
to soften the surface a trifle and raise a little nap. It
is then ready for the ground.

GROUND: Take 1 measure of Zinc White, 1 measure
of Gilder's Whiting, put them through a sieve if there
are any lumps or grains, and mix the two together thor-
oughly while still dry powder. Then take 1 measure
of Glue-water (not too hot, just lukewarm) and add it
slowly to the powder, stirring all the time with a
spatula or very stiff brush, or rubbing between the
hands, until all lumps or grains have disappeared and
you have a perfectly smooth creamy mixture.

> *Note:* For those unaccustomed to using for-
> mulae this does not mean that you add a measure
> of glue-water equal to the Zinc White and Whit-
> ing combined. It means that if, say, one cup is
> the measure used, then you take one cupful of
> Zinc White, one cupful of Whiting, and one cup-
> ful of Glue-water.

Lay the canvas flat and with the same sort of brush
as that used for the gluing, apply this mixture lightly.
Care must be taken not to use the brush too heavily
charged. As in the gluing, the ground should go only
half way through the canvas and not soak all the way

through. On no account should it be scumbled on or heavily scrubbed on.

As soon as the canvas is evenly covered, take the Broad Knife (see under *Notes on Materials*, p. 50) and lightly scrape it, taking long steady strokes with the knife first lengthways, each stroke the full length of the canvas, and then sideways, at right angles to the first scraping, each stroke the full width of the canvas. This should be enough scraping, but if there seem to be spots where there is still too much ground, scrape it again lengthways and again sideways. If there is a tiny spot or two where the canvas shows through the ground, this can be touched up with a drop of ground on the finger, but it must be done quickly for the ground sets very soon into a state where it is liable to pull off or roughen if touched or rubbed.

If a heavier ground is desired, wait ten to fifteen minutes, then apply a second coat of the mixture with the brush, and scrape as before. If three or more coats are applied, the result will probably be too absorbent. For most purposes, one should be enough.

Set the canvas to dry for at least 48 hours, never in the sun or near a stove — the normal room temperature is enough — and then coat generously with a 5 per cent solution of Formalin (Formaldehyde) in water. (Obtainable at any drug store.) This tans the ground or toughens it so that it becomes insoluble in water. Allow it to dry for another 24 hours. When dry, the ground so made and treated should not rub off and should not dissolve in water.

We have always found that this *Chalk Ground* (always referred to as such in this book) is the best for Gouache, thin Tempera using the "Lean" emulsions such as egg and water, or for the Lean Tempera not too thickly painted. For this tempera thickly painted,

however, or for Putrido or Oil, it is too absorbent.
The oily mediums sink in, leaving only a crust of paint
on the surface which is apt to scale off.

TEMPERA GROUND

1 Measure Glue-Water
1 Measure Zinc White
1 Measure Gilder's Whiting
1/3 to 1/2 Measure Linseed Oil

Note: The amount of oil is only one third to
one half of the single measure used in measur-
ing the glue, the zinc white, the whiting, and
not one third of the volume of these three
measures put together. See note under *Chalk
Ground.*

The canvas is to be rubbed with pumice-stone, glued
and again lightly rubbed with the pumice, precisely
as described for the *Chalk Ground.*
 The Whiting, Zinc White, and Glue-water are to be
mixed and stirred precisely as described for the
Chalk Ground. When the mixture has cooled
somewhat, to about the temperature of the hand or
cooler, but before it begins to stiffen, add the Linseed
Oil very slowly at first, drop by drop, stirring the mix-
ture constantly. As it absorbs the oil a little, it is
possible to add the oil faster. When all the oil is in,
and well stirred into the mixture, apply it to the canvas
and scrape, precisely as described for the *Chalk
Ground,* except that in this case it is desirable to apply
two coats. The first coat should be allowed to set for
about 10 or 15 minutes, before applying the second.
 This ground should be allowed to dry at least 10
days, better two or three weeks, before using. It is
not to be treated with the Formalin solution.
 When dry, test it for flexibility by pressing with the

finger from behind the canvas. The ground should not crack under reasonable pressure.

We have found this ground to be the best for all general tempera painting, especially those forms using the "fatter" or oilier emulsions, such as *Putrido*. If the full quantity of 1/2 measure of linseed oil is added to the ground, it will also be found to make a good semi-absorbent ground for ordinary oil painting.

All grounds containing linseed oil show a tendency to turn yellow, especially if stored for a long time in the dark. Doerner says that this is not dangerous; but remember to expose them to the light for a short time before painting on them, and they will bleach out almost white. To reduce this yellowing to a minimum, we advise the use of sun-bleached oil (see note on *Linseed Oil,* p. 53).

TEMPERA PANEL

For small panels up to, say, 3 or 4 feet, good quality five-ply veneers may be used, provided they are of hard wood. Pine and other resinous woods should be avoided. Three-ply is too thin, except for panels used for practice purposes, sketches, etc., where permanence is not essential. There is however no particular virtue in ply-wood, except its cheapness and lightness. The woods used in their manufacture are usually of inferior quality, and there is always a danger of warping or of the layers blistering or splitting apart.

The best panels, whether for large or small sizes, are made by gluing together heavy hard-wood * boards, or planks for the larger sizes. When properly glued, such panels should never split at the joints. The edges to be joined must be planed absolutely true to one an-

* Birch, mahogany, poplar, walnut, and oak are among the best.

other, and kept perfectly free from grease or oil. Use
a good quality of cabinet maker's glue, applied warm,
and clamp the boards together under strong pressure.
Plane the surface smooth for the canvas.

> *Note :* Those who have had some training in the
> elements of wood-working can easily make their
> own panels. But for the larger sizes of panels,
> and in the case of those who know nothing about
> wood-working, it is better to have them made by
> some competent carpenter.

To reduce the tension on the panel (i.e., to reduce
the danger of warping the panel) if larger than, say,
3 or 4 feet, the canvas should be cut up into smaller
squares, from 4 inches to 6 inches for smaller panels,
up to 12 inches or larger for big mural panels. To
avoid fraying the edges, and to keep them true, this
should be done with a straight edge and a sharp razor
blade.

Use Rabbit Skin Glue ("Colle de Lapin") in a
strong solution. When hot, it should have about the
consistency of thin honey.

The panel should be ruled with pencil lines corre-
sponding precisely with the sizes of the squares of
canvas. These serve as a guide in keeping the edges
true.

Apply the glue hot to the panel, one square at a
time. Apply the canvas, also one square at a time,
and work it into place with a hot flat-iron, matching up
the edges as precisely as possible.

> *Note* 1 : If the canvas has any wrinkles or folds
> in it, these should be ironed out before the cut-
> ting of the squares.

> *Note* 2 : As for all other grounds, unbleached
> linen canvas is the best. (See *Notes on Mate-*
> *rials,* Canvas, p. 48).

After the squares are all in place, turn the panel face down on a smooth floor and nail down securely all round. A few weights on top of it are not enough. Leave for several days or until completely dry. In the case of ply-wood panels, this nailing down is absolutely necessary.

It is always advisable, and in the case of ply-wood essential, to apply a strong system of cross-bars to the back to prevent warping. In the case of small panels, up to 3 or 4 feet square, these may be glued on. If the panel is thick enough, they should be both screwed and glued. This may well be done while the panel is still nailed to the floor. For larger panels, the cross-bars should be dovetailed so as to permit expansion and contraction in the panel.

The surface when dry should be treated with pumice stone and lightly sized, as for the *Chalk Ground* (p. 36). The ground used may be either *Tempera Ground* (p. 39), the *Full Oil Ground* (p. 44), or the *Non-absorbent Ground* (p. 45), depending on the type of picture to be painted on it, but for most tempera painting, the Tempera Ground will probably be the best. (For details for applying ground, see under *Tempera Ground* p. 39).

The ground should be allowed to harden several weeks before using. The panel may be given a coat of lead white and linseed oil on the back and edges, to protect against dampness from behind.

There are a number of commercial wall-boards or panels, more or less artificial or synthetic in character, which should be experimented with as to their suitability for panels for pictures.

COATED PAPER AND CARDBOARD

For small sketches or pictures on paper or cardboard, the following ground may be used:

Rub up a quantity of Zinc White with sufficient of the Medium Fat Tempera emulsion, that is, 1 Egg, 1 Linseed Oil, 2 Water, to rub the colour into a soft creamy paste. Then into this rub a little more Linseed Oil, to about 1/5 to 1/4 of the bulk of whatever quantity of Zinc White and Emulsion you may have prepared. Coat your paper or cardboard with this mixture without scraping. Two coats may be used, waiting 10 or 15 minutes between each coat.

If the paper or cardboard seems too absorbent, it should be first treated with one or two coats of a 2% solution (by weight) of animal Gelatine in water. The first coat must dry at least 24 hours before the second is applied, and both coats allowed to dry 24 hours before the ground is put on.

Paper so treated will give a good cheap surface, easily and quickly prepared, for both tempera painting and ordinary oil painting.

Paper treated with one or two coats of the *Tempera Ground*, p. 39, also works well for tempera painting.

OIL GROUNDS

FULL OIL GROUND
NON-ABSORBENT GROUND

FULL OIL GROUND

1 Measure Glue-Water
1 Measure Gilder's Whiting
1 Measure Lead White
1 Measure Linseed Oil

The canvas is to be rubbed with pumice-stone, glued and again lightly rubbed with the pumice when dry, precisely as described for the *Chalk Ground*, (p. 36).

The Whiting, Lead White, and Glue-water are to be mixed and stirred precisely as described for the *Chalk Ground*. Then the Linseed Oil is to be added slowly, drop by drop at first, stirring constantly, precisely as described for the *Tempera Ground;* only in this case a full measure of the oil is used, that is, one measure equal to the unit measure used for the glue-water, whiting, etc. The mixture should be quite cool before the oil is added, as it will not take the oil well when hot. The oil when added, drop by drop at first, and later a little at a time, should disappear almost at once into the creamy mixture as it is stirred. If it remains on the surface separate from the mixture, it means that you are adding the oil too fast. Sometimes there is difficulty in making the mixture take the full amount of oil, but prolonged stirring will make it absorb the full quantity. Apply two or three coats to the canvas, scraping each one and waiting 5 or 10 minutes between each coat. Allow it to dry at least two weeks before using.

This gives an excellent non-absorbent ground for

ordinary oil painting, when the full gloss or shine of
oil paint is desired. When the medium used is the 1
part oil, 1 part turpentine, 1 part Damar varnish (1
to 3) (see *Damar Varnish,* p. 56) a painting on this
ground should retain its full gloss for several years
without further varnishing being necessary.

Owing to the large quantity of linseed oil in it, this
ground is liable to turn very yellow if stored in the
dark for any length of time ; but if exposed to the light
before using, it returns to its normal creamy white.
To reduce this yellowing to a minimum, we advise
the use of sunbleached oil (see note on *Linseed Oil,*
also note under *Tempera Ground*).

NON-ABSORBENT GROUND

1 Measure Gilder's Whiting
1 Measure Lead White
2 Measure Glue-Water (1 part Glue to 15 parts Water)
1/2 to 2/3 Measure Oil and Damar (see below, Step 3)

STEP 1 : The canvas is to be rubbed with pumice-stone
as for the other grounds. Use 6 parts glue to 100 parts
water by weight. This should soak all night. Then
heat it gently in a double boiler, and allow it to cool
and set ; this may take another 24 hours. When cold
it should set in a soft jelly, not tough and rubbery,
but slightly stiffer than ordinary dessert jelly. This
jelly is then applied to the canvas with a palette knife,
care being taken to coat the canvas evenly and to scrape
off any surplus glue from the surface. Allow the can-
vas to dry 24 hours or more.

STEP 2 : Take 1 part Whiting, 1 part Lead White, and
2 parts Glue-water (1 part glue to 15 parts water by
weight). This is a stronger solution of glue than that

used in Step 1. When cold it sets as a stiff rubbery jelly.

Mix these three ingredients together and rub smooth, precisely as described for the other grounds.

STEP 3: Take a small portion of Damar varnish in crystal or powder form and add enough turpentine to moisten or just cover it. Heat this until the Damar melts and mixes with the turpentine. This must be done carefully, as the turpentine is inflammable. Then take 4 to 6 times this amount of Linseed Oil and mix the oil and Damar together. Of this mixture, take 1/2 to 2/3 of the single unit measure used in Step 2, and stir it into the mixture of Whiting, Lead White, and Glue-Water.

> Note: If, say, one pint is the measure used in
> Step 2, then the whole formula reads as follows:
> 　1 Pint Gilder's Whiting
> 　1 Pint Lead White
> 　2 Pints Glue Water (1 Glue to 15 Water)
> 　1/2 to 2/3 of a Pint of Oil and Damar Mixed
> 　　(1 Damar to 4 to 6 Oil)

The final mixture of Step 2 and Step 3 should then be gently warmed in a double boiler for about 15 minutes, stirring thoroughly but taking care not to let it boil.

Allow it to cool a little and while still warm but not hot, apply it to the canvas and scrape, precisely as described for the *Tempera* and *Chalk Grounds*. As many coats may be put on as desired, up to four or five. The more coats applied, the smoother and more non-absorbent will be the surface. It should dry two weeks or more before using.

This ground is the best one to use for paintings done entirely in the *Maroger Oil Emulsion* (see

Example 7, p. 73, *Summary of Procedures*), which de-
mands an absolutely non-absorbent ground. When,
however, the underpainting is done in Putrido or
Pastose Tempera, it should be done on the Tempera
Ground, this form of tempera underpainting, when
dry, being sufficiently hard and non-absorbent to carry
the Maroger or oil overpainting.

> *Note on Step* 3 : It is possible to substitute Rosin
> for Damar Varnish but the only reason for doing
> so is the sake of economy, Rosin being much
> cheaper than Damar. But we do not recom-
> mend its use, as it is so much more brittle than
> Damar. This ground when well made should
> give a hard egg-shell like surface, and yet remain
> supple and flexible enough to avoid cracking
> when tested with the finger from behind.

NOTES ON MATERIALS

CANVAS: The best canvas of all for painting is unbleached hand-made linen. The more nearly your canvas approaches the qualities of this material, the better. The next best material is hemp, or a combination of hemp and linen. Duck or cotton canvases should be avoided.

A good canvas should stretch as little as possible; i.e., it should not "give" when pulled strongly lengthways or sideways.

Certain types of sail-cloth are good for small pictures, but most sail-cloth is too tightly woven; that is, the ground cannot penetrate into it far enough to ensure its holding permanently to the canvas. The grain should be fairly open, but not too open. Grains such as sack-cloth or even burlap are too open.

If there is any starch or colouring material in the canvas, it should be thoroughly washed out before stretching.

All canvas, once stretched, should be rubbed with a piece of fine-grained flat pumice stone. (Obtainable at any hardware store.) Rub with a circular motion, lightly and evenly all over the canvas, until it feels smooth and velvety to the palm of the hand. This raises a fine nap or fuzz which greatly improves the surface of even inferior grades of canvas, and makes the glue and the ground stick more securely. All lumps and knots should be rubbed down with the pumice as much as possible, but be careful not to rub through any of the threads which may later start a "run."

STRETCHING: In stretching a canvas, care should be taken to avoid any diagonal strains. The pull should

48

be straight along the direction of the threads, both
lengthways and sideways. When stretched, run the
hand round on the surface. If the canvas feels "soft"
in spots, these parts should be carefully re-stretched
until the tension is perfectly even all over. Tempera
paintings on canvas will not stand re-stretching as well
as oil paintings do. It is therefore important to have
the canvas well stretched for tempera paintings.

STRETCHERS: The ordinary stretcher sold in the com-
mercial art stores is too light and weak. A strong can-
vas well stretched on such stretchers soon pulls and
warps them out of shape. This is especially bad in
the case of certain forms of tempera which become too
brittle in the course of time to permit of re-stretching
without danger of the colour flaking off the canvas.
Keyed stretchers are convenient but unnecessary.
Good canvas properly stretched on strong stretchers
should always keep its tension.

TACKS: Ordinary iron tacks soon begin to rust ; and if
your pictures are exposed to the least dampness, the
rust under the heads of the tacks eats away or rots the
canvas until it easily pulls over the tacks and the whole
canvas must be re-stretched. For this reason copper
tacks are best.

BRUSH: A wide thin brush such as house-painters use
for applying colour-washes to walls is best for applying
the glue and the grounds. It should be at least six
inches wide and about a quarter of an inch thick, with
bristles about two inches long.

WHITING: Various filling-stuffs may be used for spe-
cial sorts of grounds, such as Chalk, Lime, Gypsum,
Pipe Clay, and others, but the best material for ordi-
nary oil and tempera grounds is Gilder's Gesso or
Gilder's Whiting.

This is a fine white powder which should be kept

dry in an airtight container, and put through a fine sieve before using.

Be careful of Lithophone which is sometimes sold as Whiting. It changes colour and becomes a dark slate gray under the action of light and humidity.

BRUSHES FOR TEMPERA: For small paintings up to 3 or 4 feet square, the cheap soft brushes mounted in quills (which can be easily attached to longer wooden handles if desired) with hairs an inch or so in length, work very well. For larger paintings, such as mural size panels, ordinary soft house-painter's brushes work very well. For fine details ordinary water-colour brushes are satisfactory.

BROAD KNIFE: A wide-bladed putty-knife, 4 to 6 inches wide, is used to scrape the canvas after each coat of ground. These are commonly called Broad Knives, and may be found in any hardware store.

GLUES

ORDINARY Fish Glue should never be used in making grounds. It causes cracking, and is liable to mildew if exposed to the least dampness. It can easily be distinguished from better glues. In sheet form it is cloudy and opaque, with a greyish-green tinge running through it, and the sheets are usually thicker than other glues. It often contains refuse material in addition to fish.

The best glue for grounds is Totin Glue, or "Colle Totin." This is made in France from the cartillage of calves. This comes in thin sheets, and is very clear and transparent, the colour of very light honey. But it is expensive and difficult to find.

The best cheap glue readily available is French Rabbit Skin Glue, each sheet stamped "Colle de Lapin." This comes in thin sheets, is fairly clear and transparent, and is the colour of brown honey. If the glue appears too dark, or has a blackish tinge to it, it has probably been burnt and should be rejected. It should feel dry and hard. To test it, drop it on the floor. The clearer and sharper the sound it makes, the better the quality. Also moisten a bit and taste it. If it tastes salty, it contains too much acid and is not good for grounds. If it tastes slightly soapy, it is safe to use.

Other tests for good glue: Lay a sheet to soak in a plate of cold water. If it is good glue, it should within 24 to 48 hours absorb double its weight of water. By then it should be perfectly supple but still rubbery; that is, it should show no signs of dissolving

until the water is heated. If it begins to dissolve in cold water, it is not good for grounds. Also the best glues when soaked as above should discolour the water very little or not at all.

LINSEED OIL

LINSEED OIL, though it has certain disadvantages inherent in it, yet remains one of the indispensable mediums for painting.

One purpose of this book, as already stated, is to show how to combine as many of the advantages of using Linseed Oil as possible, with as few of its disadvantages as possible.

One of the chief troubles with it is that in drying, especially over long periods of time, it invariably darkens or yellows more or less. Also, in drying, it always dries from the outside in; that is, it forms a skin on the outside which cuts off the interior from the oxygen in the air, so that thick masses of paint rubbed up with linseed oil may be quite hard and dry on the outside, and still comparatively soft on the inside.

The best grade of Linseed Oil obtainable should always be used, preferably "cold pressed" or "first pressing." In the second pressing, the flax is treated with hot water or steam, which produces an inferior grade of oil. Unfortunately, what with blending good oil with second grade oil, it is extremely difficult to distinguish between first rate oil and other grades. The best most artists can hope for is to find a reputable oil manufacturer or colour manufacturer who can be trusted to supply them with genuine "first pressing" oil.

Linseed oil should not be used too fresh. It should stand at least six months, better one year, and then be carefully strained to remove vegetable impurities found in the freshly crushed oil.

SUN-BLEACHED OIL: There is some difference of opinion among authorities as to whether sun-bleached lin-

seed oil remains light in colour when deprived of
strong light, or whether it eventually returns largely
to the normal colour it had before bleaching. We can
only say that we have kept oil, bleached to a very pale
straw-colour, in dark bottles in a dark corner of the
studio, for over three years, and that it showed no signs
of returning to its former dark colour. Also paintings
done with this bleached oil showed far less tendency to
darken or turn yellow than those done with un-
bleached oil. We therefore recommend its use, and
in this book, wherever the use of Linseed Oil is men-
tioned, unless otherwise specified, it should be under-
stood that sun-bleached linseed oil is intended.

It is possible that some of the oil sold commercially
as sun-bleached linseed oil is in reality bleached with
chemicals. It is therefore advisable to do one's own
bleaching in the sun.

BLEACHING: This is more easily and quickly done in
summer, when you can count on long hours of strong
sun-light. Wide shallow pans are necessary. The
big white enamelled pans used in the markets to dis-
play fish are excellent. Place the oil in these pans
to a depth of no more than half an inch. The shal-
lower the oil, the quicker it will bleach. Expose the
pans of oil to strong sunlight. It is best to cover them
with a sheet of glass to protect the oil from dirt or
water in case it rains. A low glass-covered case like a
hot-bed for lettuce, etc., works very well. The length
of time the oil takes to bleach varies with the condi-
tions under which it is exposed. It will probably take
ten days to two weeks or more. The oil should be
stirred at least once a day to prevent too much skin
from forming. When it seems to have bleached as
much as possible (different oils bleach to various de-
grees of whiteness—a pale straw yellow is about as

white as most ordinary oil will go) but before it begins to thicken, strain the oil through a fine cloth to remove particles of skin, and put it away in bottles.

SUN-THICKENED OIL : Thickening oil in the sun is done in precisely the same way as bleaching, except that the pans used should be made of lead, which acts as a catalytic agent and speeds up the thickening process. Expose these pans, filled with oil half an inch deep, to the sun, under glass, as above, and stir them well at least once a day. After a few days, a white cloudy sediment will begin to appear at the bottom. Later the oil seems to jelly in places, and these jelly-like parts must be well stirred into the more liquid re- mainder. The oil may be thickened to almost any desired consistency. For all purposes called for in this book, it is sufficiently thick when it can be picked up in "gobs" on a palette knife.

It should be well strained through fine cloth, prefer- ably while the oil is still fairly hot. Even then, if it is at all thick, some pressure will be necessary to pass it through the straining cloth ; and it is almost impossible to do so when the oil is cold.

DAMAR VARNISH

DAMAR VARNISH is used so much in tempera painting that it is a great saving for the artist to prepare it himself. It comes in the form of small lumps or crystals, is pale yellow in color and usually rather cloudy and opaque, the clearer and cleaner crystals being the better grades.

These crystals should be reduced to powder form. This may be done with a small coffee mill or finely-set meat grinder, but care must be taken to grind slowly; otherwise so much heat is developed in the grinding that the Damar begins to melt and clogs up the grinder.

For all the emulsions described in this book, the strength of Damar called for is: 1 part Damar to 3 parts Turpentine *by weight*. But for other purposes, such as the varnishing of oil paintings, other strengths may be needed, such as 1 to 4 or 1 to 5. These are prepared as for the Damar 1 to 3, only the quantity of turpentine is varied as desired.

DAMAR 1 TO 3

For 1 part of Damar crystals in powder form, take 3 parts of turpentine by weight. Prepare two or three small sacks of fine muslin or gauze (2 or 3 thicknesses of cheap cotton mosquito netting will do) and put the Damar powder into these. Tie them up with string and then suspend these sacks in the turpentine so that they are under the surface but do not touch the bottom of the container. Allow this to stand two or three days until all the Damar is dissolved in the turpentine, and repeat the process until the required quantity has been prepared.

The reason for using the little sacks is that if the Damar is simply put into the turpentine, it settles to the bottom and jellies into a thick sticky mess.

The container of turpentine may be put in the sun, or in some warm spot where there is no danger of fire, to make the varnish dissolve a little more quickly.

When all the Damar is dissolved, the resultant varnish should be carefully strained through a fine cloth and put away in bottles. It is easy and practicable to make fairly large quantities at one time, as it keeps indefinitely.

Mastic Varnish may be prepared in precisely the same way.

The varnish so prepared may be slightly cloudy as compared with the bleached commercial product, but this is in no way harmful.

> *Note :* The container of turpentine should be kept covered to prevent evaporation.

LEAD WHITE

CAUTION : In handling Lead White, especially when it is in dry power form, as in the rubbing up of tempera colours, the greatest care must be exercised. Even in the form of oil colour, a certain amount of it may get into the human system through continual handling of dirty paint-rags, etc., and once there, it remains until enough has accumulated to affect the health of the individual.

When in dry powder form, it is even more dangerous, as it may then be breathed in directly from the air. Care should be taken to see that there are no drafts to blow it into the air when the powder is placed on the marble slab for rubbing, that if you get some on your hands you do not dust your hands against one another or on your clothes, and that all knives or measures used in handling the powder are washed in water.

It is very easy for a slight accident to cause the powder to get into the air, and it is therefore strongly advisable to wear a damp fine cloth over the mouth and nose whenever handling Lead White in powder form.

GOUACHE

ORDINARY Gouache, though not strictly a form of emulsion tempera painting, is nevertheless so useful and convenient and gives effects so similar to Lean Tempera painting, that we include a note on its preparation and use. It is especially good for small sketches on paper which are later to be worked up as larger tempera paintings.

Gouache colours are rubbed up in Gum Arabic and painted with water as a medium. For greater strength and permanence they may be painted with the *Lean Tempera* emulsion or with *Egg and Water* emulsion.

In painting with Gouache, it is usually found that a great deal more white is used than any other colour. It is desirable therefore to mix one's own white. We have always found that the other colours behave so differently when prepared as Gouache, and so little of them is used as compared with the white, that it is cheaper and easier to mix one's own white but to use good commercial tube colours for the other colours.

The following method of mixing Gouache white, though a rough-and-ready method, has been found to give excellent results. Jars of white so prepared have been found in good condition three years after mixing, only water being added to the mixture from time to time. Paintings done with this mixture three years ago are still in excellent condition.

Powder your Gum Arabic and dissolve it in cold water to the consistency of very thin mucilage. Test by rubbing a drop between thumb and finger. As it dries, it should feel only slightly tacky, not definitely sticky as with glue. With a pestle on the glass palette, rub up as much Lead White or Zinc White as you wish

to prepare with the solution of Gum Arabic to a soft creamy paste. This paste should have a sticky quality. Rub a piece of fine-quality glycerine soap between the hands in water until you have a thick lather. Add this lather to the soft paste of white and Gum Arabic, a little at a time, rubbing it into the paste with a palette knife until the paste loses its sticky feeling and takes on a light fluffy creamy consistency. A few drops of pure glycerine may be used instead of glycerine soap-suds, but we have always found that the soap-suds give a far finer creamy consistency to the mixture, making it easier and pleasanter to handle. If the mixture seems insufficiently sticky, a small amount of honey may be added, say, a quarter of a teaspoonful of honey to a pint of the mixture, but this is not essential. This Gouache white may be painted with either water or any of the Lean Tempera emulsions.

When dry, it should be sprayed with a 5% solution of Formalin. When painted with water only, Gouache should *never* be used as an underpainting. When painted with a Lean Tempera emulsion, it *may* be so used, but it is always dangerous, as the stronger fatter tempera on top of it is likely to pull it off the canvas.

Most "show-card tempera," so-called, is usually some form of Gouache, and should *never* be used as an underpainting for oil.

MAROGER OIL EMULSION

THIS emulsion of boiled linseed oil, varnish, glue, and water is the discovery of M. Jacques Maroger, based on many years of experiment stimulated by his experience in restoring old paintings. It has been subjected to exhaustive tests by M. Mourier-Malouf of the Louvre Laboratories, who states that in its chemical and microscopic structure it closely resembles samples, similarly tested, taken from pictures by the old Flemish Masters, or by the Venetian School of the time of Titian.

The following notes on the technical processes of the Old Masters, apropos of the emulsion, are condensed from an article by M. Maroger:

The grinding of colours in linseed oil as we know it today was clearly described by the monk Theophilus in the 12th Century, who also mentioned one of its chief disadvantages. He said ". . . each time that you are going to apply a colour, you cannot super-impose one on top of another until the one underneath is dry. . ."

The addition of some sort of siccative agent to the linseed oil gives us the technique of direct oil painting in common use today. However, this process of painting was not much used until the 15th Century, fresco and tempera paintings being more favoured by the artists. But about the beginning of the 15th Century Van Eyck profoundly modified the character of oil painting. His secrets, in spite of himself, became known and Antonello da Messina introduced them into Italy, whence he is sometimes wrongly claimed as the discoverer of oil painting. This new method of oil painting with some variations lasted until about the end of the 18th Century, when it underwent consid-

erable changes, dropped out of use and was finally lost.

At the beginning of the 15th Century, John Van Eyck had a choice of two different systems of painting: on the one hand that with a glue base (or tempera) which dries too quickly and is too opaque; and on the other hand painting with an oil base or an oily varnish, which dries too slowly. In an effort to combine the qualities of these two methods in one medium, he must certainly have discovered that an oily fat substance can only be mixed with a watery lean substance by means of an emulsion, which he did with some sort of glue-water.

The resultant emulsion when used as a medium for painting gives far greater richness and variety to the paint-quality, conserves the texture and character of the brush stroke, permits of superimposing one stroke on top of another without their sinking in, and gives much greater transparence and luminosity to the colours. When this medium is used with colours ground in linseed oil, in more or less equal proportions, the particles of pigment are separated one from another. The drying of the medium is practically complete. When exposed to the air it dries as a mass, all through, owing to the evaporation of a certain amount of the water contained in it, which leaves minute openings by which the air can reach the lower layers. This is a distinctly different process from that of ordinary linseed oil painting, which dries from the outside in, first forming a skin which keeps the air from reaching the paint underneath.

Though the principle of the emulsion remained the same, there were developed two different manners of making it. The northern painters such as the Flemish used transparent glues such as casein or gum arabic. The southern painters such as the Venetians preferred

less brilliant and less transparent glues, such as skin glue. These two forms of the emulsion give distinctly different results.

THE following further notes on oil emulsion painting are translated from papers read by M. Jacques Maroger and M. George Mourier-Malouf before the French Academy of Sciences:

"Applied Chemistry. Reconstruction of the pictorial technique of John Van Eyck. Note by M. Jacques Maroger.

"The common procedure of painting used today makes use of raw linseed oil to grind and dilute the colours. The brush stroke is opaque and slippery. These obstacles are insurmountable for the realization of a pictorial technique resembling that of the best periods.

"The ideal for the painter is to have a vehicle which does not dry too quickly, which goes on smoothly, is permanent and permits of the superimposing of colours.

"John Van Eyck, dissatisfied with the technique of painting with raw linseed oil because it dried too slowly, a technique already known in the 12th century, also dissatisfied with the techniques of glue or egg because they dried too quickly, must certainly have had the idea of combining these two processes into a single one from which developed the new technique which was called Oil Painting, and which lasted about four hundred years.

"The secret of this composition, which we believe we have re-discovered, depends on the use of an emulsion. The value of the emulsion is to give to the varnish a consistency and smoothness which makes it practical for use and adds to the brush stroke a transparency which oil alone was incapable of giving it. But to give this emulsion a certain stability it is important to add a glue (gum arabic or skin glue). This glue fixes the brush stroke more firmly and with greater clarity to whatever is underneath.

"The formula which after numerous trials has given us the best results is the following: — pure Flemish linseed oil of the first pressing, made more siccative by the addition

of 3% to 6% of burnt lead white, salts of lead (litharge) and raw umber in equal parts. Cook this over a gentle fire until the scum turns brown.

"The salts of lead and of manganese should, by their catalytic action, assure the thickening and the oxidization. The cooking may be for a short time at a high temperature, or for a longer time at a lower temperature. To this cooked oil is then added a resin, (one or two parts of oil to one of resin). This gives us the varnish.

"To obtain the emulsion, one has only to mix the varnish with the gum arabic in a mortar, the proportions varying as desired. Introduce the water drop by drop, stirring to the desired consistency.

"The resulting emulsion is both permanent and transparent. Also, its solidity and firmness permits of superimposing brush strokes without slipperiness, which cannot be achieved by any of the processes now in use.

"We feel justified in stating that this formula is extremely close to that of John Van Eyck. For if the emulsion permits the realization of pictorial techniques of which we have appreciated the similarity in the course of our experience in restoration, we have also had the opportunity to observe the following particulars which are a confirmation of our opinion. According as the vehicle used is gum arabic or skin glue, the resulting emulsion permits us to achieve pictorial effects similar to the Flemish school or to the Italian school. Before the discovery of John Van Eyck, the Flemish illuminations were painted with gum arabic, the Italian with skin glue.

"To sum up, this process may be considered as a reconstruction of that process, formerly widely used, which had completely disappeared well before the beginning of the 19th Century." * .

"Applied Chemistry. Further remarks on the Reconstruction of the Pictorial Technique of John Van Eyck. Note by MM. Jacques Maroger and George Mourier-Malouf.

"It may be recalled that the secret of the pictorial tech-

* Extract from the "Comptes rendus des séances de l'Academie des Sciences," t. 193, p. 740, séance du 26 octobre, 1931.

nique of John Van Eyck, which one of our members believes he has re-discovered, is based on the use of oil and resin emulsified in a glue-water. New experiments covering a period of several months allow us to describe more precisely certain characteristics of this product, for which we will use the word 'medium.'

"This medium when dry is transparent. Under the miscroscope it is seen to be made up of an infinite number of tiny, superimposed, oily-resinous particles, held together by a binding material which is also transparent.

"Thus we have a juxtaposition of two different optical systems, the one continuous, the other discontinuous, each one having its own index of refraction.

"Because of the separation of the pigments, which are united by their affinity to the oily-resinous particles, we have a total optical power and a chromatic value which is extremely high with a minimum quantity of pigment. This is a result which one cannot obtain by the procedures now in common use, which are dull whereas the medium is luminous.

"Because of the actual structure of the emulsion, we achieve the best possible pigmentary separation. The pigment, because of its affinity for the oily-resinous particles, combines with these the moment it is introduced into the emulsion. Certain authorities consider this to be a phenomenon of electrolysis. It is not possible for us to state definitely at the moment whether the pigment places itself on the periphery or in the interior of the oily-resinous particle, or whether there take place between the pigment and this particle any osmotic exchanges. Whatever happens, the distribution of the pigment in the medium obeys a definite rule for each pigment. Thus, lead white and vermillion introduced simultaneously into the medium distribute themselves each in a different way, without there being any contact between the two pigments.

"The interpigmentary separation thus realised is of the greatest possible value, since it gives us security against any further chemical reactions which might result from a more intimate contact between the pigments. This phenomenon explains the perfect preservation of the pictures of the Old Masters.

"In the procedures in use today, the oil dries by surface oxidization, forming an outer skin which retards the drying process of the paint underneath.

"This defective drying leads to the formation of cracks and fissures which lead us to have very little faith in the permanence of modern oil painting. In contrast to this, the medium because of its structure dries as a mass all through. It undergoes no change, and once dry, its transparency convinces us that the brush stroke will always preserve its luminosity and its chromatic character." *

THE actual manufacture of the emulsion mentioned above is somewhat difficult and disagreeable, as the linseed oil while cooking gives off quantities of extremely bad-smelling smoke and vapour. It has been patented under the name of "Maroger Medium" and is now available on the market in the United States, England and France.

* Extract from the "Comptes rendus des séances de l'Academie des Sciences," t. 197, p. 766, séance du 9 octobre, 1933.

SUMMARY OF PROCEDURES

IN the following examples of procedures, we have summarized the more important methods of painting described in this book and presented them in concise text-book form, with the idea of assisting beginners to gain enough experience with various forms of tempera painting and underpainting to make their own experiments.

EXAMPLE I

For a Light Airy Transparent Thin Tempera Picture

SUGGESTION

1 : Use Chalk Ground canvas.
2 : Use as emulsions 1 Egg, 2 Water—or 1 Egg, 1 Damar, 2 Water.
3 : Use either good quality tube Gouache colours or dry colour rubbed up with the emulsion 1 Egg, 1 Damar, 2 Water.
4 : For slightly pastose parts, use Combination White.
5 : When picture is finished and dry, spray with a 5% solution of Formalin to render surface tougher and more insoluble, especially when using plain Gouache with water.
6 : All general painting to be done thinly.
7 : Picture cannot be varnished, or only with great difficulty and danger.

EXAMPLE II

For all General Tempera Painting
For Laying in First Stages of Underpainting

SUGGESTION

1 : Use Tempera Ground Canvas.
2 : Use as emulsion 1 Egg, 1 Linseed Oil, 2 Water.

3 : Use colour rubbed up with the same emulsion.

4 : Use in early stages of painting plain Tempera White, i.e., white rubbed up with the above emulsion. Later, for more pastose painting, shift to Combination White or to Putrido White. For extra thick pastose, use Putrido White.

5 : Picture may be varnished if desired, but with great care. Use Damar 1 to 5 (1 part Damar to 5 parts turpentine by weight), or according to Doerner, a 5% solution of animal gelatine in water.

6 : Do NOT use White of Egg as varnish.

7 : In combination with this Example, the tempera colour and emulsions of Example 1 and Example 3 may both be used.

8 : While painting is still damp, mistakes can be easily wiped out with a sponge and water.

EXAMPLE III

For Pastose Tempera Painting
For Putrido Tempera Painting

SUGGESTION

1 : Use Tempera Ground Canvas.

2 : Use colour rubbed up with the emulsion 1 Egg, 1 Oil, 2 Water, or rubbed as Putrido.

3 : Use as emulsions 1 Egg, 1 Oil, 2 Water — or 1 Egg, 1 Sun-thickened Oil, 2 Water.

4 : Use either Combination White or Putrido White.

5 : When thoroughly dry (two or three weeks at least, better several months) Putrido Tempera or Pastose Tempera provide an excellent surface for further overpainting with oil paint or the Maroger Oil Emulsion.

6 : May be safely varnished with Damar 1 to 5, 4, 3,

as desired. It should dry at least six months, better one year.

7 : Putrido colours putrefy easily in warm weather. It is not advisable to use them when bad.

8 : When using the sun-thickened oil emulsion, the brushes do not wash out easily in plain water. As they become clogged, they must be washed out with soap and water.

9 : In combination with this Example, the tempera colour and emulsion of Example 2 may be used.

EXAMPLE IV

For a Pastose Oil-Putrido Tempera Picture

SUGGESTION

1 : Use Tempera Ground Canvas, Full Oil Ground, or Non-absorbent Ground.

2 : Use ordinary tube oil colours (or self-ground oil colours) with oil-Putrido White, or the entire palette rubbed up as oil-Putrido.

3 : Use Linseed Oil as a medium, or some form of the ⅓ Oil, ⅓ Damar, ⅓ Turps medium. Do not use Turps alone.

4 : Use oil-Putrido White.

5 : The picture when dry may be safely varnished. It should dry at least six months, better one year.

6 : It is possible to use this method as an underpainting for oil or oil emulsion but it is not advisable. It is already too fat for a good underpainting. It is better to use it solely as a variation on direct oil painting. It dries more quickly and more solidly, is more permanent, and is pleasanter to handle than ordinary oil paint, though it dries

with a more or less dull surface and is perhaps
better varnished.

EXAMPLE V

Mixed Technique

For an unusual technique which offers great variety
of treatment, but which presents considerable diffi-
culty, it is possible to use Examples 2, 3, and 4 on the
same canvas simultaneously.

SUGGESTION

1 : Use Tempera Ground, Full Oil Ground, or Non-
Absorbent Ground.
2 : Use both Tempera-Putrido and Oil-Putrido col-
ours.
3 : For painting with the Tempera-Putrido use as
emulsions 1 Egg, 1 Oil, 2 Water—or 1 Egg, 1
Sun-thickened Oil, 2 Water. Use Tempera-
Putrido White.
4 : For painting with the Oil-Putrido, use linseed oil;
or oil, Damar and turps; never turps alone.
Use Oil-Putrido White.
5 : Care should be taken not to paint too thickly until
the composition is well set. The leaner Tem-
pera-Putrido may be painted on top of the fatter
Oil-Putrido, while the latter is still wet. It is
also possible to paint the fatter Oil-Putrido on
top of the leaner Tempera-Putrido, but only
when the latter has had time to set (say half an
hour or more); otherwise it will be pulled up by
the fatter stickier paint. In practice it may be
found that this method of painting works best
only in small areas, crisp lines, spots, fine deco-
rations, etc.; that is, it does not work well

where large planes of Tempera-Putrido are laid over the Oil-Putrido, or vice-versa. It should be reserved for a final enrichment of lines, script, decoration, or where greater clarity and precision of the pictorial form are desired, and not as a means of radically changing large areas of the picture.

6: When dry, Oil-Putrido takes Tempera-Putrido very well, or even the tempera colour and emulsion of Example 2. This is useful where it is desired to continue with an old canvas for correction, etc., or if the old canvas is too dark, it may be covered with a thin film of transparent Tempera White, and then heightened in key, while still retaining the old composition.

7: Can be safely varnished when thoroughly dry (at least six months, better one year).

8: See Max Doerner's "The Material of the Artist" for a different form of the Mixed Technique.

9: Of all the techniques of painting, this is one of the most difficult, and one requiring a great deal of experience and constant practice to get the best results.

EXAMPLE VI

For the Use of the Maroger Oil Emulsion

SUGGESTION

1: If the entire painting is to be done with the Maroger Oil Emulsion, use the Non-Absorbent Ground. Rub the canvas before painting with this emulsion thinned out with a little oil. Rub on with a bit of rag and only the thinnest possible film. Wipe afterwards with a dry cloth.

This is done solely to facilitate painting with the sticky emulsion.

2 : For underpainting, use Tempera Ground and Putrido.

3 : The Maroger Oil Emulsion is to be used as a medium with ordinary oil colours, or with your own oil colours self-ground. The emulsion may be rubbed into the colours when setting out the palette, or mixed with the brush as each colour is taken.

4 : Use linseed oil for thinning out the emulsion if it is too sticky. Care must be taken not to dilute too thinly; no oily sauces. These will shrivel and crack in drying.

5 : There is always a temptation to paint with too much emulsion alone, owing to its great transparency and luster. The emulsion must be well loaded with pigment, even for thin transparent painting. If a shrivelled skin appears on the surface of the picture after drying for a week or so, this is a sign that too much emulsion is being used.

6 : If the picture dries out dull within a few days, it may be a sign that not enough emulsion is being used. It may also be a sign that the underpainting or the ground is too absorbent. A little experience will soon show which is the fault.

EXAMPLE VII

For Use of Maroger Oil Emulsion both for Underpainting and Overpainting

SUGGESTION

1 : Use Non-Absorbent Ground.
2 : Rub canvas before painting with emulsion thinned with oil. (See Suggestion 1, Example 6.)
3 : Use linseed oil to thin out the emulsion.
4 : Use ordinary tube oil colours, or your own oil colours self-ground.
5 : Paint your underpainting with these using the Maroger Oil Emulsion as medium. It should dry for at least six months before overpainting.
6 : Complete the overpainting in the same way, using the emulsion as medium.
7 : If both ground and emulsion are in good condition, such a painting should not need varnishing for years.

INDEX

DATE DUE

May 9

CPSIA information can be obtained
at www.ICGtesting.com
Printed in the USA
LVHW061935160723
752503LV00005B/257